Ozomatli
monkey

Ocelotl
jaguar

Ferdinand Anton

The Secret World

of the

Mazatl
deer

Tecpatl
flint knife

AZTECS

Xochitl
flower

Quiahuitl
rain

Cuauhtli
eagle

Actl
reed

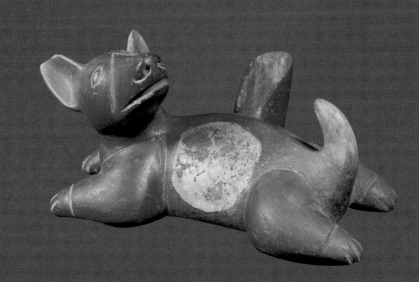

Itzcuintli
dog

Prestel

How the Aztecs came to Mexico

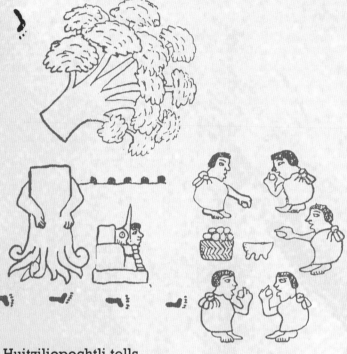

Huitziliopochtli tells the Aztecs to leave the other tribes.

The Aztecs were a wild but cultured people among many hundreds of others in ancient America. They called themselves Mexica. Although their beginnings are lost in mystery and legend, they came from Aztlan, from the high north, said the old folk. Others told how they had found their tribal god Huitziliopochtli—whom they called the "Humming Bird of the South"—in the Seven Caves. Some time around 1225—after moving from place to place for over two hundred years—they are thought to have reached the fertile upland of the Mexican Plateau. Initially they were not liked at all by the tribes that had already settled there, and it wasn't until another two hundred years had passed that they managed to set themselves up as a real power.

The Aztecs had no alphabet. Instead, they painted series of pictures on a kind of paper made of beaten plant fibers or on deerskin. These pictures told the traditional stories of their beginnings. Many of these long series of drawings—or pictographs as they are called—tell of the rulers' families or give priests instructions as to when to make sacrifices to the gods.

This pictograph shows the Aztecs setting off in "year one flint knife," according to their calendar, with the footprints showing the direction taken. After many years of being on the move, they find their tribal god Huitziliopochtli in a mountain cave. He was their sun god and god of war.

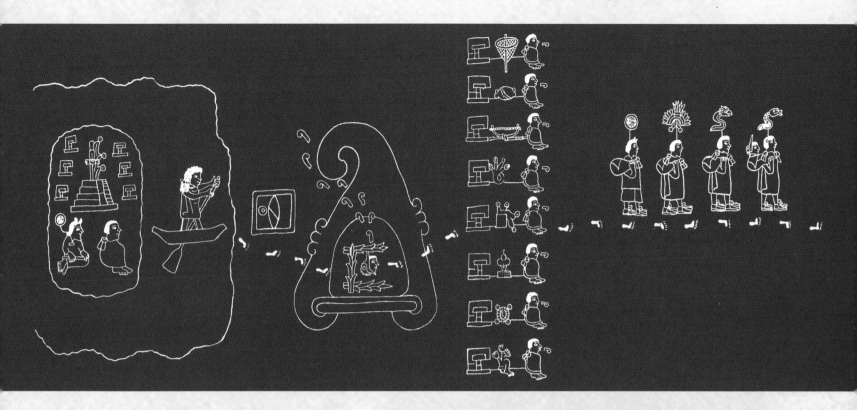

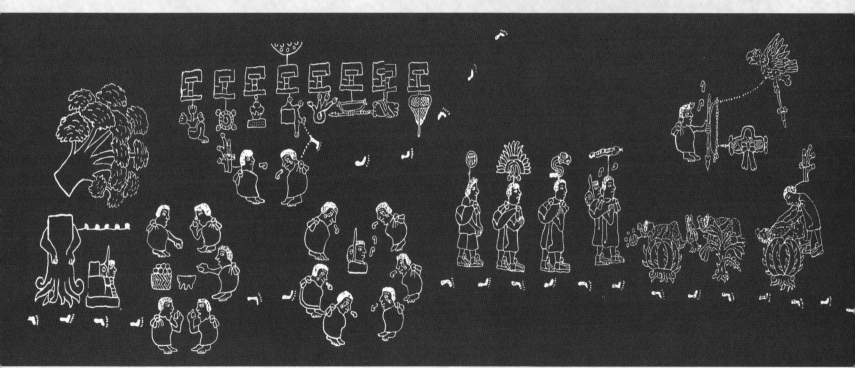

At the "place where the tree broke," Huitziliopochtli tells them to leave behind the other eight tribes that had come with them. After a lot of tears, they obey their tribal god.

The Founding of Tenochtitlán

"Big things only come from many small steps," says an Aztec proverb. According to legend, the Aztecs would find their homeland where they saw an eagle sitting on a cactus with a snake in his beak. They found him on a marshy island in the middle of Texcoco lake. There they set up their first houses and built a small temple, calling the place Tenochtitlán. Less than 150 years later, the Aztec city could boast of over 70,000 temples, palaces, houses and other buildings, with between 100,000 and 200,000 inhabitants.

It must have been a splendid city when the Spanish conquistador Hernán Cortés arrived in 1519. Shortly afterwards, however, the ancient city of Tenochtitlán was completely destroyed. Mexico City, now home to over twenty million people, was built on the same site.

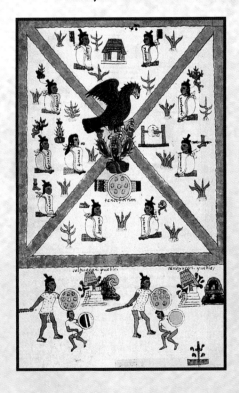

This pictograph shows the various tribes conquered by the Aztecs. In the middle is the eagle—who told them where to settle—sitting on a cactus. The lower part of the picture shows Aztecs fighting other tribes. In the end they win, and the enemy's temple falls into ruins.

A bird's eye view of how Tenochtitlán once looked. You could only enter the city via the causeways. Drawbridges were built to block the enemies' path.

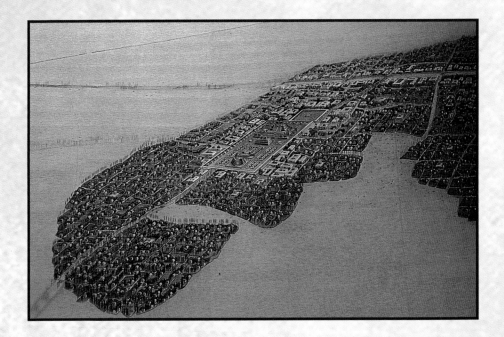

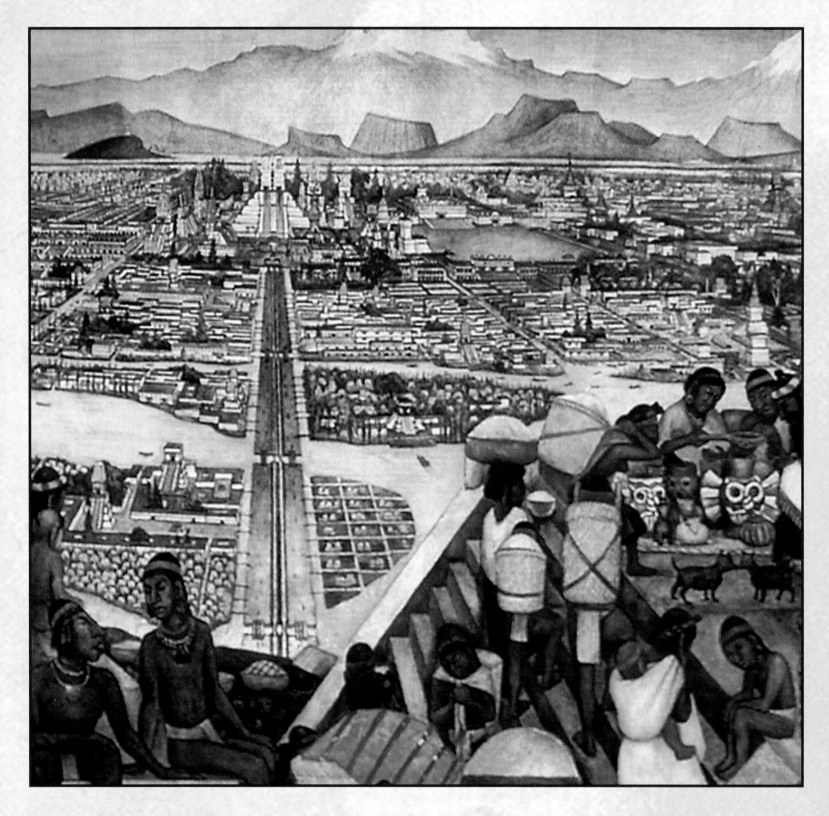

In 1946, more than four hundred years after the destruction of the Aztec empire, Mexican artist Diego Rivera (1886–1957) painted huge murals in the National Palace telling the history of his country. The city of Tenochtitlán in its heyday can be clearly seen, too. It was built on an island in the middle of Texcoco lake. The lake has long since dried out, and the modern capital Mexico City was built on its bed.

The "Dirt Eating" Goddess, the "Flower Prince" and Other Gods

The two main temples of Tenochtitlán stood on a huge pyramid-like structure that could be seen from a long way away. Seemingly endless steps led up to them. One temple was dedicated to the tribal god Huitziliopochtli, the other to the rain god Tlaloc. Apart from these two, many other gods were also worshipped. And if the Spaniards had not conquered Mexico, there would have been still more. This was because, every time they conquered another tribe, the Mexica adopted the gods of the defeated people and added them to those in Tenochtitlán.

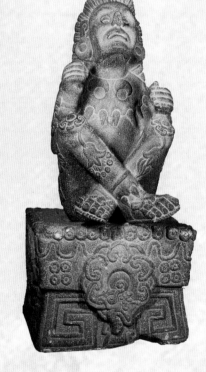

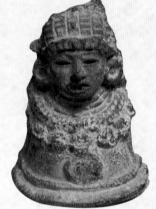

This thumbnail-size clay figurine shows Chalchiuhtlicue, goddess of springs and water.

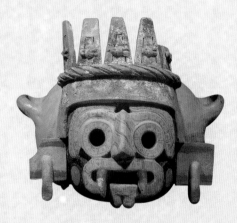

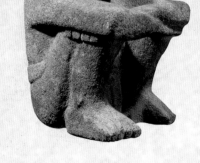

This incense burner from a temple shows the rain god Tlaloc.

This is Xochipilli, the "Flower Prince." He was in charge of festivals, music, song and games, and was also patron of craftsmen.

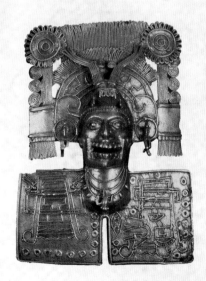

The "Old God" was considered the god of volcanoes. His missing tooth is a symbol of great age. A lot of pictures also show him with a wrinkled face.

This gold pendant contains a picture of Mictlantecuhtli, the "Lord of the Underworld" and god of death.

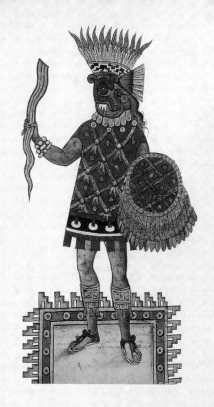

The richly dressed man carrying a shield and spear thrower, wearing magnificent headgear and with a very unusual face comes from a pictograph. He is either Tlaloc the rain god, or a priest in a mask showing him at a religious festival.

Among the most important gods were Coatlicue (the "Dirt Eater") or goddess of sin, and the water goddess Chalchiuhtlicue. Xochiquetzal ("Precious Flower") was the goddess of beauty and love, while Ometecuhtli ("Lord of Duality") was one of the gods of creation. There were two sides to the powers of every god. If Tlaloc sent just a little rain and at the right time, his gift was thought of as a blessing. If he did not get it right, droughts or floods were the consequence. How to keep the gods alive and in a good mood was something the priests knew from the pictographs.

On the edge of what is now the capital city, there is an Aztec pyramid all on its own, which was not destroyed by the Spaniards. Catholic monks and nuns built the Saint Cecilia Monastery nearby. By doing this they believed that they would be able to get rid of the "heathen curse" from pre-Christian times.

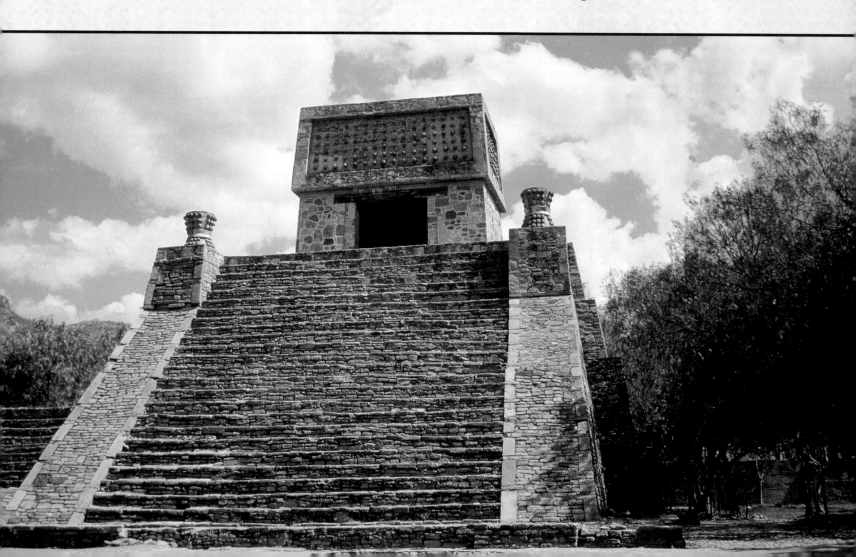

The Ruler and his People

The emperor was called *tlatoani*—"he who speaks." His palace stood near the main pyramids. His garden was a zoo with animals, flowers, and plants from all parts of Mexico. He lived in luxury and never wore the same clothes twice. Every kind of food the country could offer was served at his table. None of his subjects was allowed to look at the emperor. He traveled around in a litter—a chair that it carried on poles—and servants hurried on ahead to sweep the streets and clear the way. In their youth, most emperors were brave warriors—if they were not, they were not allowed to become emperor.

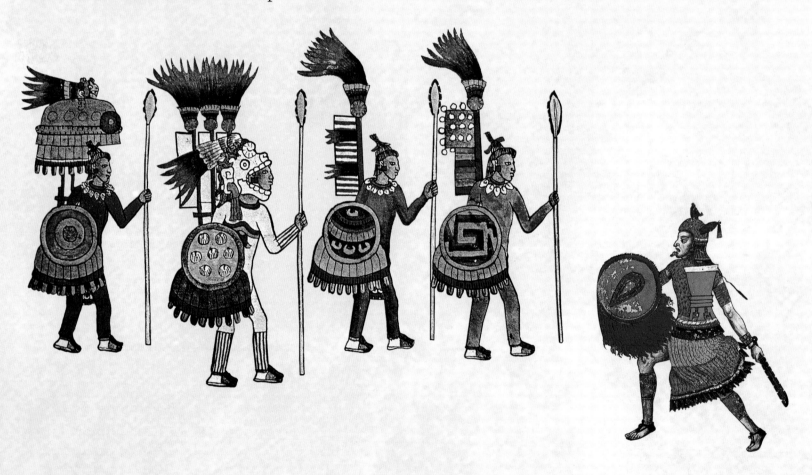

Warriors in full armor carry richly decorated circular shields and long spears with tips made of obsidian—a volcanic glass that is formed when quartz melts during a volcanic eruption.

On the right, Nezahualcoyotl, the "hungry coyote," can be seen. He was ruler of Texcoco, a town near Tenochtitlán. He was a friend of the Aztecs, and famous not only as a warrior but also as a poet.

Not only gods or important people were carved in stone as this sculpture of a simple old man shows. The only piece of clothing he is wearing is a loincloth made of cotton.

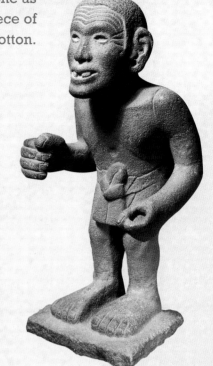

The nobles—high priests and those working for the government—held the second highest rank in the country. Then came craftsmen and the farmers, who were called *tlamaitl*, or "hands of the soil." The lowest class were the slaves, who were either criminals or prisoners of war. Family trees were recorded in pictographs, which made it quite clear as to what a person owned, and what his status and his reputation were.

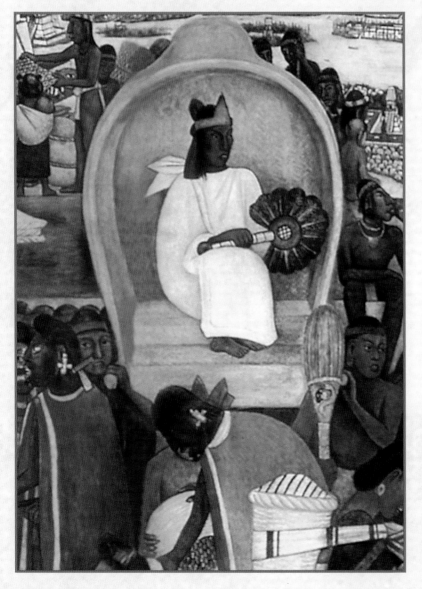

The man in the white robe on the throne is a judge. The Aztec legal system set a good example in many respects. People were never sent to prison. Instead, the guilty person was sentenced to make up for the loss or damage he had caused. Thieves and debtors could expect to become slaves to those they stole from or owed goods to, at least until the loss was worked off. Judges were administrators in villages and the suburbs of the towns. The penalty for major crimes like murder was death. However, if the victim's widow forgave the murderer, the punishment could be changed to slavery.

Mr. 3-Monkey •••

and Mrs. 8-Flower ••• ▬

Knowledge about the passing of time was recorded in pictographs, and was a key to the priests' power. They were the ones who said when the crops should be brought in, the bush burnt back, and maize or sweet corn sown. They also organized countless festivals in honor of the numerous gods.

The Aztecs had a normal calendar with eighteen months of twenty days each, i.e. 360 days in all. The remaining five days of the year were declared unlucky, and all activity was suspended. However,

The manuscript shows the gods which were needed to help corn grow. These pictures are like a comic strip—except they have to be read from right to left!

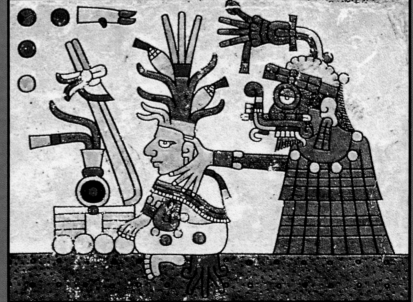

The seedling breaks through the ground and a red-painted war god helps the young maize and frightens the birds away.

Tlaloc the rain god helps out when it's time to push through the earth's crust. You can recognize him by his eyes, which look like glasses!

This is a so-called "year bundle" carrying the symbol 1-Death. Stone sculptures like this were kept in the temples. The reed-like marks around the bundle show the years. Altogether fifty-two years make up an Aztec "century." At the end of this time, the priests would put out the torches burning in the temples and people smashed all their cooking pots because they believed that the world was about to end. When the sun rose again the next day, the priests lit a new fire and people danced and celebrated. The calendar meanwhile started all over again with the same numbers and signs—1-Reed, 2-Flintstone, 3-House etc.

the most important calendar was divided into 260 days. In this, twenty hieroglyphs (e.g. for "house" or "monkey") were combined with digits from one to thirteen to produce 260 day names. Days were called 1-Reed, 2-House or 3-Monkey, for example. This calendar served mainly to tell good or favorable days apart from bad or less favorable ones. We know of the Mixtecs, a people the Aztecs conquered, that they were named after their birthdays, e.g. Mr. 8-Deer or Mrs. 3-Wind. If the sign was a bad one, they were allowed to move their birthday by up to four days.

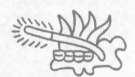

All twenty symbols of the Aztec calendar can be found on the first two pages of this book. Numbers were written with a combination of lines and dots.

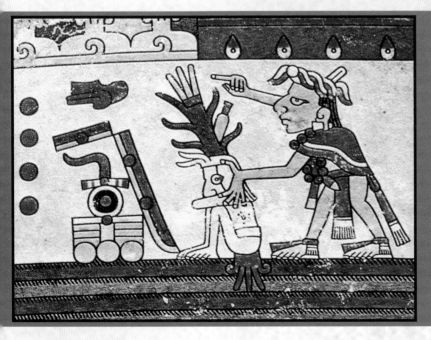

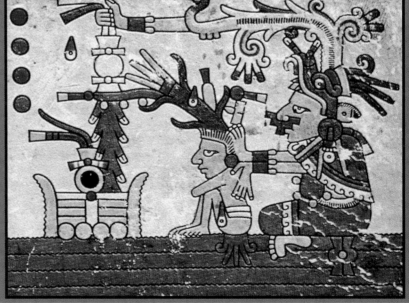

In this picture, Tepeyolotli comes rushing to help. He controls the inner forces of the earth, and protects the young plants from rotting in the soil or from being taken by the birds.

On the right, the water goddess Chalchiuhtlicue can be seen. She has made a mistake and given the young maize one pitcher of water too many!

What Aztec Children had to Learn

The Aztecs were a wild, warlike folk when they arrived in the Mexican uplands. At the peak of their power, they were highly educated. Long before all children were made to go to school in Europe, schooling was normal in Tenochtitlán. The first playthings boys had were toy weapons given to them by their fathers. Girls were given things for weaving and spinning by their mothers, and learnt about housework later. Boys on the other had two options depending on their character. Either they went to

Aztec life followed very strict rules. You can see in the pictographs what children had to learn. The different tasks for each age group—shown by blue dots—are explained, and the number of small, flat, maize loaves that they were allowed to eat each day is also shown.

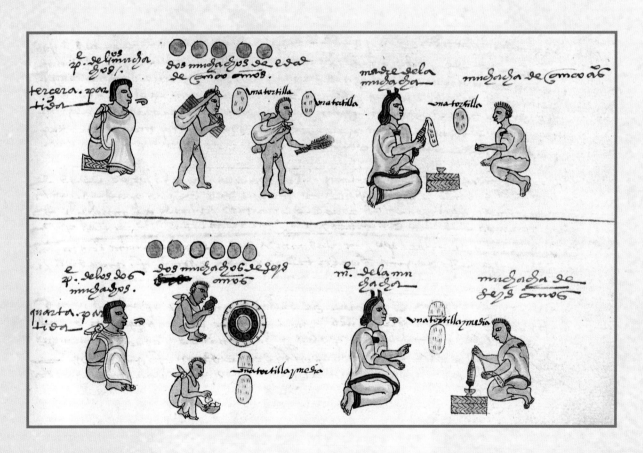

Aztec boys were not left much time to play. They were brought up so that they would be able to feed their families when they were older. At the early age of just five they had to sweep and carry. At six, they regularly helped with the harvest. They were allowed one and a half small, flat, maize loaves per day to eat.

Girls were also given different duties to carry out an a very early age. As wives and mothers, they later had to manage all household tasks. At five, they learnt from their mothers how to use a spindle for weaving. Great skill and concentration were needed to make sure the thread did not break. By their sixth birthday, Aztec girls had to be able to spin cotton by themselves.

the *telpochcalli* (Young People's House) or the *calmecac* (a kind of monastic school). These were usually open only to children of higher ranks, though farmers' children could also go there if they were brave and intelligent. Life was hard at these schools and demands were high. The reward at the end was that they could become warriors or priests. Good manners were also very important: "Don't talk too fast, and don't get over excited." "Don't let your voice go up and down much." "Stop making slurping noises when you drink, you're not a dog." This and many other things were what the Aztec children had to learn.

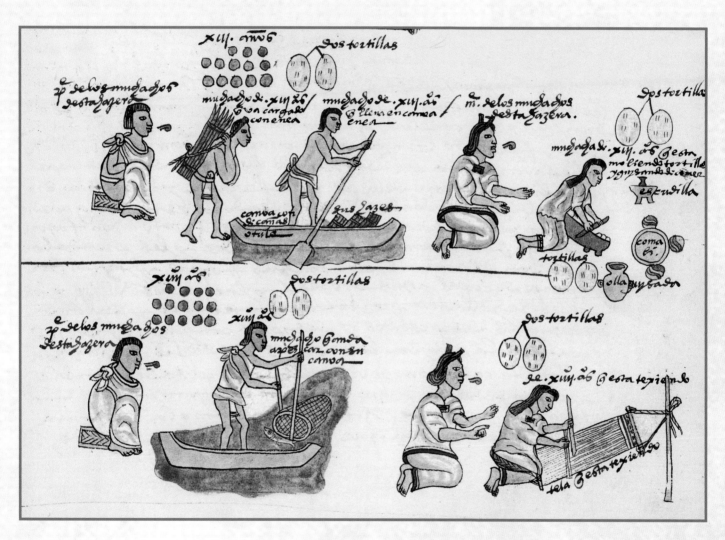

When they were thirteen, boys learned how to move things from place to place by canoe. It was not at all easy to balance in a full boat. And now that they worked harder, the boys got more to eat—two corn tortillas were now the daily ration. Families made a living from catching fish. Fourteen-year-old boys also had special tasks to do. The older people showed the youngsters how to get a specially large number of fish into a net.

Tortillas were always freshly made. Once a girl was thirteen, her mother explained how to grind corn and bake crispy thin tortillas. One of the women's most important activities was weaving. Fourteen-year-old Aztec girls quickly became very skilled at making hard-wearing clothing and practical material for the family.

Food for the Gods

The Aztecs did not go to war to make their empire bigger but to collect "tributes" from nations they had conquered. Tributes included not only food for the people but also food for the gods. Humans had to feed the gods to keep their strength up and stop the world coming to an end. That could only be done with the most precious "food" of all—human blood. To get enough humans to sacrifice to the gods, the Aztecs went to war with their neighbors at regular intervals, just as much as with others living further away. Whenever the Aztecs conquered another country, a number of warriors and officials stayed behind to collect the tributes and to make sure that there was no more trouble. Conquered nations also had to supply prisoners to be sacrificed to the gods. It was in fact a great honor for a warrior to be chosen as a sacrifice and he could then expect to go on to another heaven.

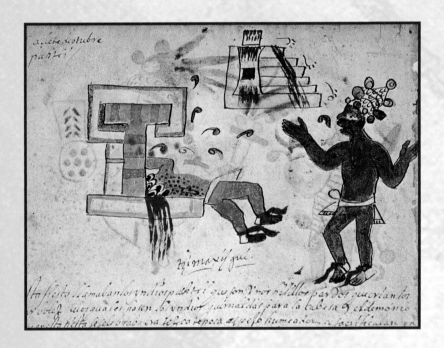

An Aztec priest dancing in front of a sacrificed victim. The strange signs coming out of his mouth are words or a song. A step pyramid can be seen in the background. The painter wanted to show that this was a sacrifice for the gods.

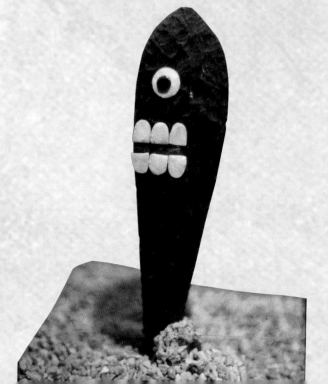

The priests cut out the hearts of their victims with knives like this one in order to offer them to the gods. Unlike the usual blades made of obsidian or flint, the blades used by sacrificial priests had a face with teeth and eyes made of whitish shell pieces and polished black obsidian.

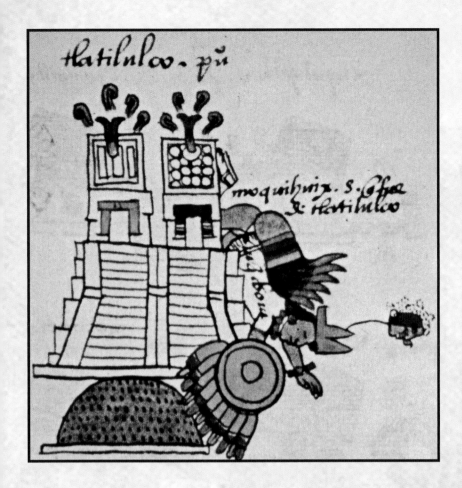

This drawing shows the conquest of Tlaltelolco. Its ruler Moquihuix throws himself off the pyramid because he is so unhappy. In fact, his name means "sick from drinking too much *pulque*," which is an alcoholic drink made from the juice of the agave plant. The temples are on fire, as can be seen from the thick smoke rising above them. The city of Tlaltelolco was on the same island and was founded by another tribe. At first, the people of Tlaltelolco lived peacefully side by side. They were mainly traders, while the Mexica, as the Aztecs were still called, were warriors, first working for other cities and later for themselves. According to tradition, the Aztec ruler Axayacatl was supposed to have defeated the ruler of Tlaltelolco on the platform of the temple in a duel in 1473. The capture of the pyramid was a sign of victory and the end of the war.

right: An Aztec "jaguar warrior" has caught one of the enemy who is being held by the hair and made to kneel down. One of two possible fates awaits him: either he will have to live as a slave or he will be sacrificed to the gods.

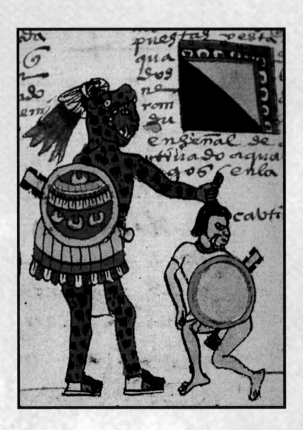

left: An extract from a "tribute list." The people now under Aztec rule were told exactly what and how much they had to give to the Aztecs. The symbols show the quantities: one flag meant twenty, for example, and one feather four hundred. All these goods were then sent to Tenochtitlán.

Swapping Rabbits
for Pots

Like other peoples of ancient America, the Aztecs did not have money. They swapped goods—or bartered, as it is called. In a letter to his emperor Charles V, the Spanish conquistador Cortés described the market in Tenochtitlán: "The main square is twice as big as the one in Salamanca. Day after day, 60,000 people come here to barter. All goods imaginable from all parts of the empire can be found here, food and clothing, as well as objects made of gold, silver, copper, precious stones, coral, feathers, and many other things. There is a special area for turkeys, quail, wild duck, hawks, and eagles. There are also rabbits, hares, deer, and fattened dogs, which are a popular food in these parts. One area is devoted to herbs and medicines. Another to earthenware jugs, pots, and pans.

This picture was painted by the artist Diego Rivera in the National Palace in Mexico city. The market is full of life. The Aztecs did not use money; instead, they agreed on a certain value and swapped goods to this amount. Rabbits were exchanged for cotton, sweet corn for tomatoes. Anything and everything was swapped. If the price was higher than the value of the other goods, the extra was made up with gold dust, kept in quills. The merchants

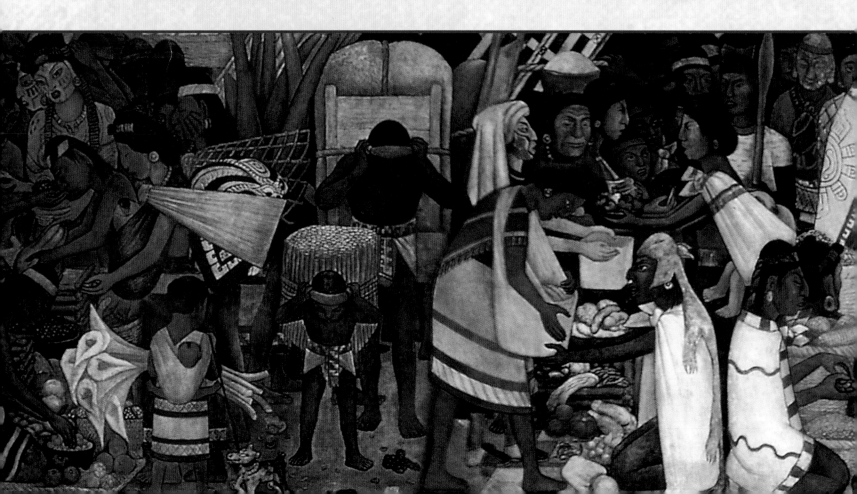

This wall painting shows a traveling merchant or envoy. His rich jewelry, the leopard-skin loincloth, and his face tell us he is a Mayan who has come from an area of the lowlands that the Aztecs traded with.

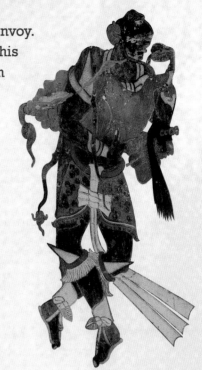

In yet another area, corn is sold as grain or baked dough bread." Mexico's richness is clear in Cortés's description. In short, thought Cortés, you could buy anything here and in whatever quantity, regardless of where it grows or lives, and of a quality not to be found anywhere else. But this does not mean that all Aztecs lived like lords. Simple people of the lower classes lived a very modest life. Traveling merchants, who were often away for years, were looked up to. They did not just bring back exotic goods to the capital city, but also brought information. Sometimes they even acted as spies.

carried their goods around on their backs and often came from a long way away to sell their wares. Once they had set up their stands at the market they spread out their goods and told everyone at the top of their voice what they had to swap. This wall painting shows a traveling merchant or envoy. His rich jewelry, the leopard-skin loincloth, and his profile indicate he is a Mayan who has come from an area of the lowlands that the Aztecs traded with.

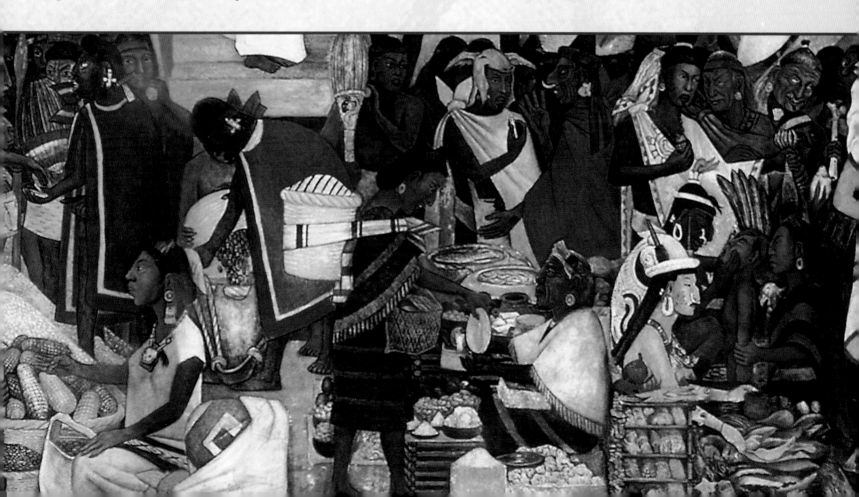

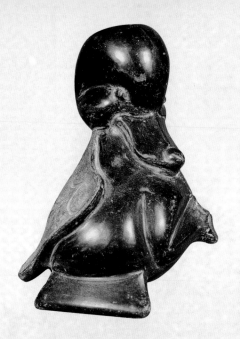

Tomatl and Chocoatl
Eating and Drinking

Apart from dogs, guinea pigs, and turkeys, the ancient Mexicans had no domestic animals—pigs and cows reached the New World later, along with the Spaniards. However, the Aztecs were very successful with domestic plants. Besides herbal medicines that are still used in part today, they grew plants that are now on every western menu. Top of the list was maize or sweet corn;

There were plenty of duck in the freshwater part of Texcoco lake. The Aztecs trapped them with nets. Many became used to being close to people if they were well fed. But they never became pets like dogs or turkeys.

The Aztecs called their dogs "chichi." There were two main breeds. Both were almost hairless, very small, and could not bark very loudly.

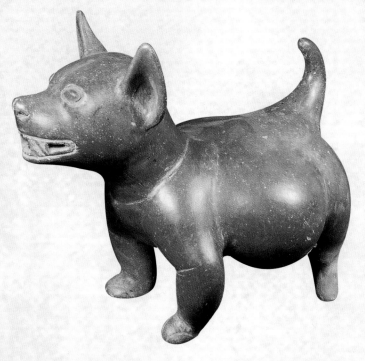

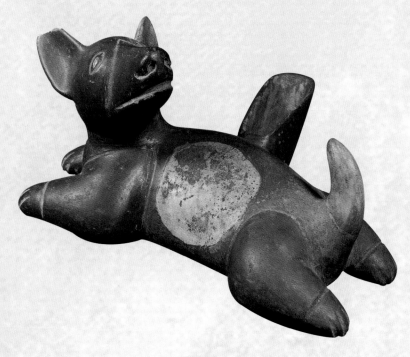

Dogs also play a major part in mythology. They accompanied a person who has just died into the realm of the dead. The Aztecs believed that, if a dog recognized its owner, it would act as a ferryman and guide his master over the wide water to Mictlan, the land of the dead.

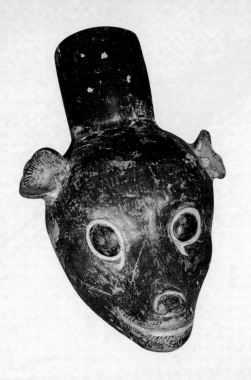

after rice it is still the second biggest staple food. For Europeans, the most important food was the potato—and from the seventeenth century onward, it ensured that a lot of people had something to eat. Some things such as tomatoes—*tomatl*—and the cocoa fruit—*chocoatl*—have even kept their Aztec names to this day. We also have to thank America's original inhabitants for certain types of bean as well as paprika, ground nuts, sunflowers, tobacco, and many other things.

This fine deer head was probably a nobleman's drinking cup. Only higher-status people could hunt deer and eat their meat. Peasants were not allowed to hunt at all. On the rare occasions that they ate meat, they probably had turkey or fattened dog. Sometimes fish and frogspawn were added to the ordinary man's diet.

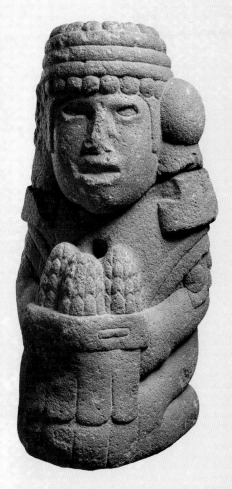

Maize or sweet corn, one of the most important types of food for simple folk, was thought of as a source of many different things that the body needed. This is why the corn goddess was worshipped so much. She was known by her calendar name of Chicomecoatl, or 7-Snake. Generally she is shown with corn cobs, as in this stone sculpture (*right*).

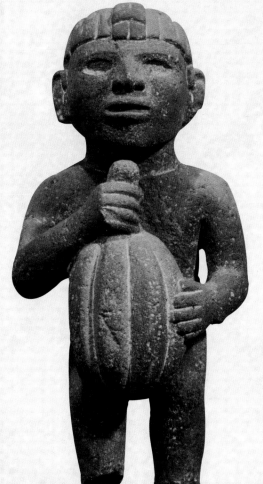

A boy is holding a large cocoa fruit. We still use the Aztec name for the food made from its seeds. Both "chocolate" and "cocoa" come from *choco + atl* (cocoa + water). *Chocoatl* was the last Aztec emperor Montezuma's favorite drink. The Spanish conquistador Cortés reported that it made the drinker happy and had a slight narcotic effect. Perhaps it was the combination that did it, because the Aztecs spiced it with hot chilis rather than honey.

Art and "Special Things"

Virtually none of the Amerindian languages had a separate word for "art" or "artist." The Aztecs, who were quite well up in the matter, used the word *toltecatl* for art and such "special things." This word came from the Toltecs, whose city of Tollan was destroyed in 1168. The Aztecs had passed that way in their year spent traveling around. The great statues of the gods they saw in the abandoned city amazed them. Later the place came to symbolize not just tradition but also everything special and artistic.

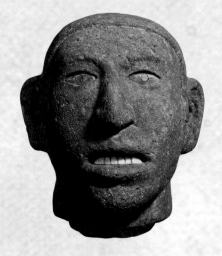

Aztecs probably looked like this. To give his stone sculpture more expression, the artist added teeth and eyes made of bits of light-colored shell and black obsidian.

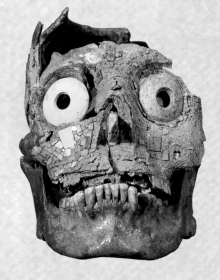

Important people were buried in special chambers. They were given jewelry and food, as the Aztecs believed they would continue their existence in the realm of the dead. Often, the dead were given a second burial years later. The skull was then decorated with a small green plaque made of turquoise. Discs made of shell were placed in the eye sockets, with pieces of polished black obsidian for the pupils.

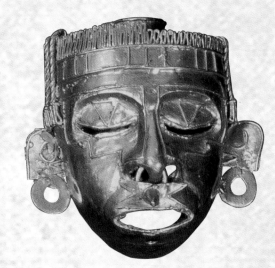

This gold mask represents the spring god Xipe Totec. During the sacrificial rites in his honor, the priests put on the skin of a victim. This was supposed to be the "new robe" of spring.

An artist who made large statues with stone tools was a *toltecatl*, i.e. something special. A legend says: "The *toltecatl* is learned, he is the skilful one. A good *toltecatl* is cautious, resourceful, clever, and discreet. The true *toltecatl* works with joy in his heart, patiently, and without haste, he goes about his work with care. . . . He arranges his materials, makes them into a whole, and creates a harmony. The bad *toltecatl* is careless and hypocritical, mocks mankind, and deceives people. He is a thief."

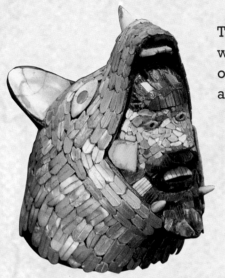

This small clay vessel is completely covered with mother of pearl. It shows Quetzalcoatl, one of the gods of creation. He introduced maize and was the patron of knowledge and education.

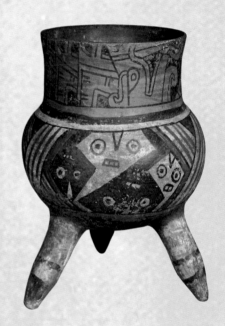

The tripod clay vessel is painted with demons. The Aztecs were very religious. Even very simple vessels, which they also gave to the dead, were decorated with gods or demonic figures. The snake with feathers on the upper edge of this vessel is a symbol of Quetzalcoatl—his name means "feathered snake."

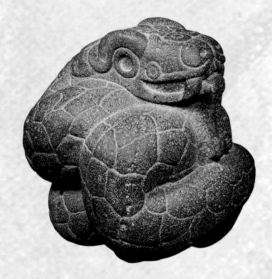

The Aztecs' love of art is also indicated by the bone instruments on the right. They are decorated with patterns or carved in the shape of eagle heads.

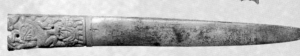

Stone images of snakes like this were on display in temples, because the snake (*coatl* in Aztec) was a symbol of earth's fertility. Snakes can often be found in pictographs—the snake is one of the day symbols in the Aztec calendar (as can also be seen at the beginning of the book and on pages 10/11).

You Are What You Wear

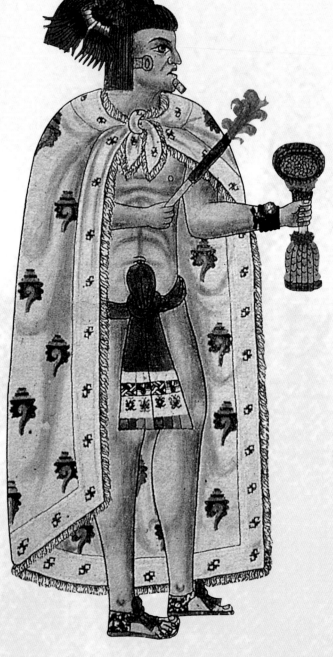

The various classes could always be told apart by their clothes. You would know some way off what sort of person was coming. Slaves for example only wore loincloths. Peasants or ordinary laborers covered the upper half of their body with a long, sleeveless shirt. Their wives and daughters wore wrap-around skirts and little blouses.

Servants stood by with fans to keep flies off their masters. The butterfly pattern in the middle of this fan is made of small feathers.

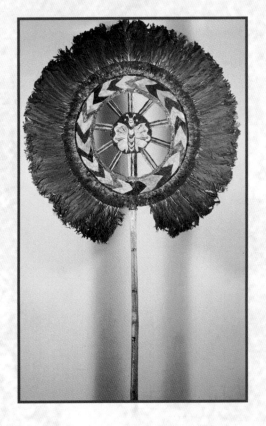

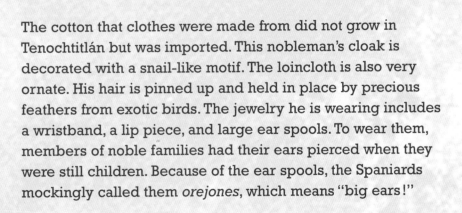

The cotton that clothes were made from did not grow in Tenochtitlán but was imported. This nobleman's cloak is decorated with a snail-like motif. The loincloth is also very ornate. His hair is pinned up and held in place by precious feathers from exotic birds. The jewelry he is wearing includes a wristband, a lip piece, and large ear spools. To wear them, members of noble families had their ears pierced when they were still children. Because of the ear spools, the Spaniards mockingly called them *orejones*, which means "big ears!"

Anyone in brightly colored, patterned garments was a high-status person. Sometimes men also wore two or three cloaks to show off their wealth and standing. Warriors belonged to various guilds or professional groups. On ceremonial occasions, they proudly wore headgear showing an eagle or a jaguar, depending on the guild (this can also be seen on pages 8 and 15). The *pochteca* or traveling merchants also stood out because of their exotic dress as well. With such differences between people's clothing and its variety, the Aztec capital of Tenochtitlán must have been one of the world's most colorful cities in its day.

A lip piece like this eagle's head in gold was a sign of special rank. It was worn beneath the lower lip, as can be clearly seen on the picture opposite.

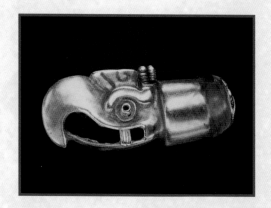

The Aztecs thought gold was dung left by the gods. It was relatively rare in their empire. Even so, or perhaps just because of this, the finest jewelry was made of it—noble families could show off their wealth in their lip and ear pieces, chains, and wristbands. This necklace has lots of raindrop-like pieces, bringing the wearer fertility and wealth.

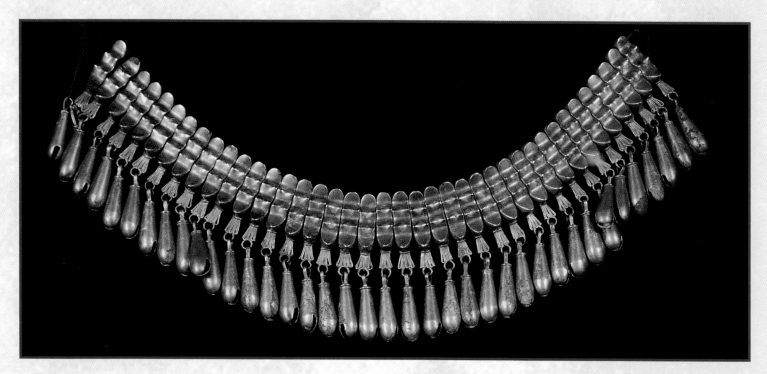

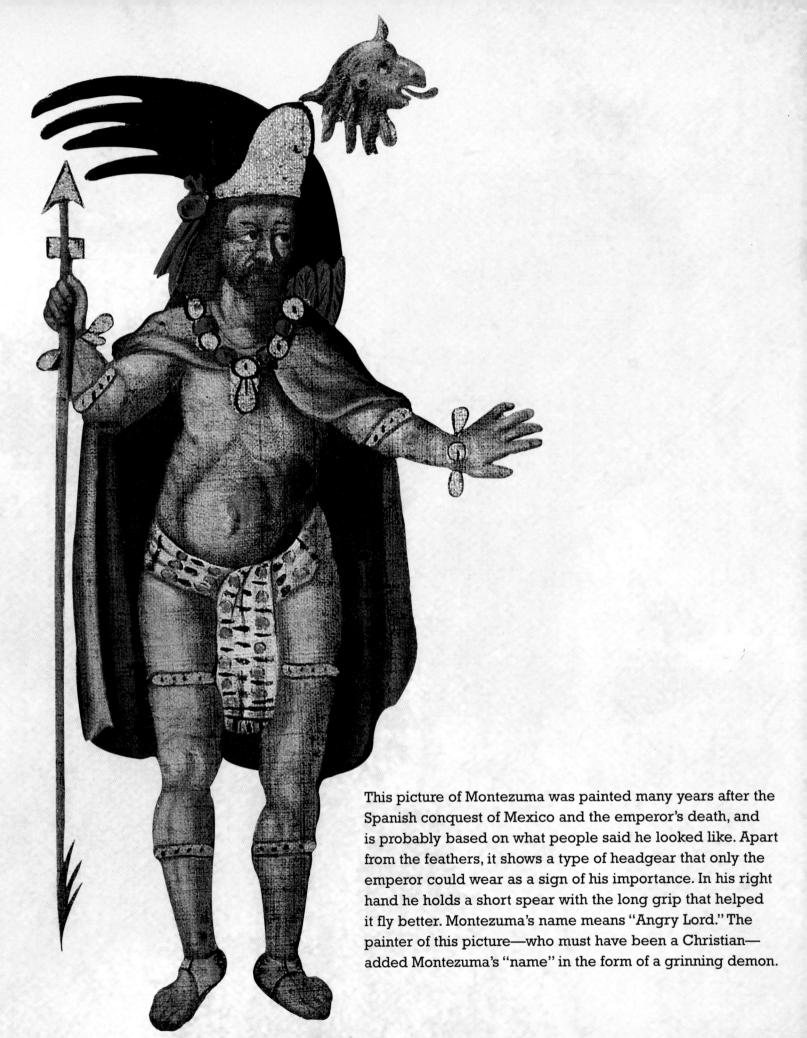

This picture of Montezuma was painted many years after the Spanish conquest of Mexico and the emperor's death, and is probably based on what people said he looked like. Apart from the feathers, it shows a type of headgear that only the emperor could wear as a sign of his importance. In his right hand he holds a short spear with the long grip that helped it fly better. Montezuma's name means "Angry Lord." The painter of this picture—who must have been a Christian— added Montezuma's "name" in the form of a grinning demon.

Montezuma — the Last Emperor

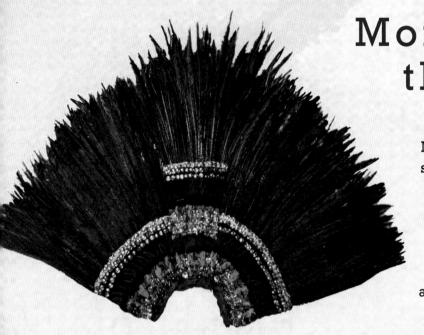

Much has been written about this headpiece. It was supposed to have belonged to Montezuma II, who gave it to Spanish conquistador Hernán Cortés at their first meeting. Cortés in turn sent it to his own emperor, Charles V, who passed it on to the King of Portugal. Made of green feathers from the quetzal bird, the magnificent piece later vanished. It finally turned up again in 1880 in a castle in Tyrol, Austria.

Montezuma II lived from 1467 to 1520. He was the great-grandson of Montezuma I and the son of the unfortunate Axayacatl ("Pale Waterface"), who was drowned in floods in 1503. Montezuma II was crowned emperor of the three cities of Tenochtitlán, Texcoco and Tacuba in the same year. This made him ruler of thirty-eight provinces stretching from the north of modern Mexico to the frontiers of the Mayan empire in modern Guatemala—an area as large as western Europe. In his youth he was a brave warrior, but he changed when he became emperor. The lively fighter of old turned into a sensitive monarch who loved poetry and art.

The Spanish invaders reported that Montezuma was slim and very distinguished-looking, and that you could only go up to him bent forward in a low bow. When the Spaniards arrived in 1519, Montezuma went out on one of the three causeways leading to his city to meet their leader Cortés. He invited the Spaniards into his father Axayacatl's palace as guests. They were treated with all the ceremony of a royal court. Soon however the Spaniards' amazement turned to greed at the sight of so much wealth and culture. When Cortés was away in the south of the country on an expedition to deal with one of his officers, the Aztecs started a big fight with their uneducated invaders. When Montezuma tried to settle the dispute, he was hit by some stones and killed. Whether they were thrown by his own people or the Spaniards is not clear. He was fifty-three.

The Destruction of Tenochtitlán

The end of the Aztec empire was very sad. The Spaniards had been welcomed into Tenochtitlán on November 8, 1519 as guests. On June 30, 1520, three days after Monetzuma's death, they were driven out of the city as devils. However, all the Europeans could remember was the wealth they had seen. They took advantage of the problems between the different tribes, and after four months of siege began the conquest of Tenochtitlán.

Using small boats built on the eastern shore, they attacked the island city from the lake. With their better military methods and Tenochtitlán's weakened defenses, the Spaniards found it all too easy.

The destruction of what was probably the largest city in the world in its day was complete. Silence reigned where once the busy life of a great metropolis had flourished. A poem, passed down by word of mouth, records the scene. It was later set down in writing and ends:

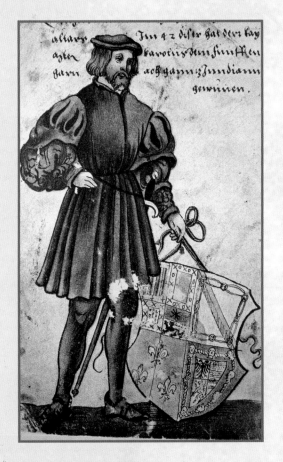

"Gold, jade, precious raiment,
Quetzal feathers,
Everything once of value
Has become nothing."

Christoph Weiditz from Nuremberg painted this picture of Hernán Cortés not from his imagination but from life. The painter happened to be in Spain when Cortés returned to his Spanish homeland, and so he had the opportunity to paint the conquistador as he saw him.

The pictures in this book

Unless otherwise stated, the photos come from Archiv F. Anton, Munich, © F. Anton, Munich. My special thanks go to my wife, and my colleague Marion Köck, also to the museums mentioned below, who allowed me to photograph their treasures and finds from excavations and to include them in this publication.

Front cover: ***Incense burner with the mask of the rain god Tlaloc*** (see p. 6)
Back cover: ***Aztec warriors*** (see p. 8)
Title page: ***The twenty symbols of the Aztec calendar*** (see pp. 10/11)
Dog-shaped drinking vessel (see p. 18)

pages 2-3: Detail from ***Tira de la Peregrinación***
Mexican Plateau, *c.* 1540. Plant-fiber paper, overall length of the 21 pages of manuscript 17' 6'' (5.35 m). Biblioteca Nacional de Antropologia, Mexico D.F.

page 4: A page from the ***Mendoza Codex***
c. 1540. European paper, 13 x 9'' (32.7 x 22.9 cm), Bodleian Library, University of Oxford, Ms. Arch. Selden. A.1.
Tenochtitlán (Mexico City) in Montezuma's day
Wall painting, Museo Nacional de Antropologia, Mexico D.F.

page 5: Detail of the mural ***The Great City of Tenochtitlán*** by the Mexican painter Diego Rivera, from the ***Precolonial and Colonial Mexico Series***. National Palace, Mexico City.

page 6: ***Incense burner with the mask of the rain god Tlaloc***
Clay, height 13'' (35 cm). Museo Nacional de Antropologia, Mexico D.F.
Large sculpture of the god Xochipilli
1275–1521. Stone (andesite), height 45'' (115 cm). Museo Nacional de Antropologia, Mexico D.F.
Figurine of the goddess Chalchiutlicue
Early Aztec, *c.* 1200–1300, clay. Height 1'' (3.5 cm). Private collection
Seated figure of the "Old God" Xiutecuhtli
c. 1275-1520. Stone with traces of painting. Height 15'' (38 cm).
Museo Nacional de Antropologia, Mexico D.F.
Pectoral with hieroglyphs with Mictlantecuhtli, god of death.
c. 1250–25. Gold, height 4'' (12 cm). Museo Regional de Oaxaca.

page 7: ***Priest wearing the mask of the rain god Tlaloc, from the Ixtlilxochitl Codex***
c. 1500–50. European paper, 9 x 13'' (24.5 x 34 cm). Bibliothèque Nationale, Paris.
Reconstruction of an Aztec pyramid in Sta Cecilia, Mexico D.F.

page 8: ***Aztec warriors from the Mendoza Codex*** (see p. 4)
Image of Nezahualcoyotl from the Ixtlilxochitl Codex (see p. 7).

page 9: ***Male figure with loincloth***
c. 1450–1520. Basalt, height 19'' (49 cm). Museo Nacional de Antropologia, Mexico D.F.
The Judge. Detail of the mural by Diego Rivera. (see p. 4)

pages 10/11: Extracts from the ***Fejérváry-Mayer Codex***
c. 1450–1520. The manuscript consist of 46 folding book pages, overall length 12' 3'' (3.74m). Museum of the City of Liverpool.
Year bundle
c. 1300–1520, Mexican Plateau, andesite, length 15'' (38 cm), diam. 8'' (20 cm). Museum für Völkerkunde, Frankfurt.

pages 12/13: ***Pages from the Mendoza Codex***
(as page 4). Photos: Bodleian Library, University of Oxford.

page 14: ***A scene from the Ixtlilxochitl Codex*** (see p. 7)
Sacrificial knife from the main temple of Tenochtitlán
Flint with shell and obsidian inlays, height *c.* 8'' (20 cm).

page 15: ***Two scenes from the Mendoza Codex*** (see p. 4)
Detail of a tribute list.
Aztec culture, 1st quarter of sixteenth century. Plant fibre paper, sheet size 16 x 11'' (42 x 29 cm). Museo Nacional de Antropologia, Mexico D.F.

pages 16/17: ***Market scene from a mural by Diego Rivera*** (see p. 5)
Traveling merchant. From a wall painting.

c. 900–1200. Height of figure *c.* 7' 2'' (2.2m). Cacaxtla, Tlaxcala State, Mexico.

page 18: ***Duck-shaped vessel***
Pre-classic period, *c.* 1000-400 BC. Black, glossily polished clay, height 6'' (15 cm), length 6'' (16 cm). Private collection, Mexico.
Reddish-brown sculpture of a hairless dog
North-west Mexico, Colima style, *c.* 100–700. Clay. Length *c.* 8'' (22 cm). Museo Nacional de Antropologia, Mexico D.F.
Dog-shaped drinking vessel
North-west Mexico, Colima style, *c.* 100–700. Clay. white painted on a reddish ground. Length 9'' (24 cm). Private collection.

page 19: ***Antler-less deerhead vessel***
Mixtec-Aztec culture, *c.* 1400–1520. Painted clay, height 11'' (28 cm). Ludwig Collection, Rautenstrauch-Joest Museum, Cologne.
Kneeling corn goddess
c. 1450–1520. Stone. Height 15'' (38.5 cm). Uhde Collection, SMPK, Ethnologisches Museum, Berlin. Photo: Bildarchiv Preussischer Kulturbesitz, Berlin 2002 (Claudia Obrocki).
Youth with cocoa fruit
c. 1450–1520. Stone (basalt) with traces of reddish paint, height 13'' (35 cm). Brooklyn Museum, New York.

page 20: ***Head of an Aztec***
c. 1400–1520. Volcanic stone, height 7'' (18.5 cm), Museo Nacional de Antropologia, Mexico D.F.
Skull of a dignitary
c. 1400–1500. Human skull decorated with turquoise plaque and shell disks in the eye sockets. Museo Regional de Oaxaca.
Jewellery with the mask of the spring god Xipe Totec
c. 1450–1520. Gold, height 2'' (7 cm). Museo Regional de Oaxaca.

page 21: ***Small cup, presumably showing the god Quetzalcoatl in the jaws of an animal (coyote?)***
c. 1000–1250. Clay with mother-of-pearl and ivory, height 5'' (12.5 cm). Museo Nacional de Antropologia, Mexico D.F.
Tripod vessel with heads of demons and a snake, Museo Nacional de Antropologia, Mexico D.F.
Mixtec-Aztec culture, *c.* 1300–1400. Painted clay, height *c.* 7'' (18 cm).
Sculpture of a snake
Mexican Plateau, *c.* 1250–20. Finely worked light grey basalt, height *c.* 13'' (35 cm). Museo Nacional de Antropologia, Mexico D.F.
Three bone carvings with various decorations
c. 1400–20. Height between 2 and 6'' (5–15 cm). Museo Regional de Oaxaca.

page 22: ***Picture of a nobleman from the Ixtlilxochitl Codex***. The name he is given there is Quauhtlatzacuilotl (see p. 7).
Fan with geometric patterns and a butterfly in the middle.
Reed and feathers of exotic birds. Museum für Völkerkunde, Vienna.

page 23: ***Eagle-shaped lip piece***
Mixtec-Aztec culture, *c.* 1470–1520. Gold and rock crystal. Museo Nacional de Antropologia, Mexico D.F.
Gold necklace.
c. 1470–1520. Museo Regional de Oaxaca

page 24: ***Montezuma II, taken from a manuscript***

page 25: Headpiece made of the tail feathers of quetzal birds attached by fine gold thread. Aztec culture, early sixteenth century. Museum für Völkerkunde, Vienna.

page 26: Hernán Cortés.
Drawing by Christoph Weiditz in his costume book, *c.* 1527.
Germanisches Nationalmuseum, Nuremberg.

pages 28/29: ***Aztec place names and their characters***

Text by Ferdinand Anton

Die Deutsche Bibliothek CIP-Einheitsaufnahme data and the Library of Congress Cataloguing-in-Publication data is available

The title and concept of the "Adventures in Art" series and the titles and design of its individual volumes are protected by copyright and may not be copied or imitated in any way.

© Prestel Verlag, Munich · Berlin · London · New York 2002

© for works illustrated by Diego Rivera: Banco de Mexico, Fiduciario en el Fiedeicomiso relativo a los Museos Diego Rivera y Frida Kahlo.

Prestel Verlag
Königinstrasse 9, 80539 Munich
Tel. +49 (89) 38 17 09-0
Fax +49 (89) 38 17 09-35

4 Bloomsbury Place, London WC1A 2QA
Tel. +44 (020) 7323-5004
Fax +44 (020) 7636-8004

175 Fifth Avenue, Suite 402,
New York, NY 10010
Tel. +1 (212) 995-2720
Fax +1 (212) 995-2733

www.prestel.com

Translated from the German by Paul Aston
Edited by Christopher Wynne

Design and layout: Susanne Rüber
Originations: ReproLine, Munich
Printing: Aumüller Druck KG, Regensburg
Binding: Conzella, Pfarrkirchen

Printed in Germany on acid-free paper
ISBN 3-7913-2702-X

Aztec Place Names—The Hieroglyphs and their Meaning

These pictures stand for individual objects or for part of a word (a consonant in a syllable)

Xalostoc
"sandy cave"

xalli = sand
oztotl = cave

Jolotlan or Xolotlan
"near the monster"
xoloth = the god of the monsters
tlan = near

Mazatlan
"among deer"

mazatl = deer
"with" or "among" is shown by two teeth ("tlantli")
which can be seen clearly in front of the deer

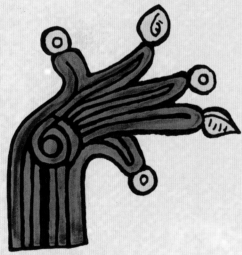

Anenecuilco
"where water changes direction"
atl = water
nenecuiltic = to change direction

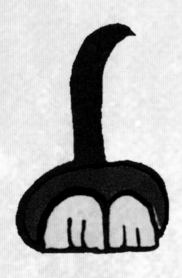

Ixtlan
"between obsidian"
ixtli = obsidian (as a consonant)

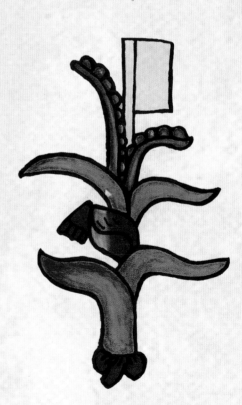

Ohuapan
"where the maize sheds its leaves"
ohuatl = where the maize
is about to burst open
pan or pantli = banner (flag)